· THIS BOOK BELONGS TO ·

THE TIMID CABBAGE

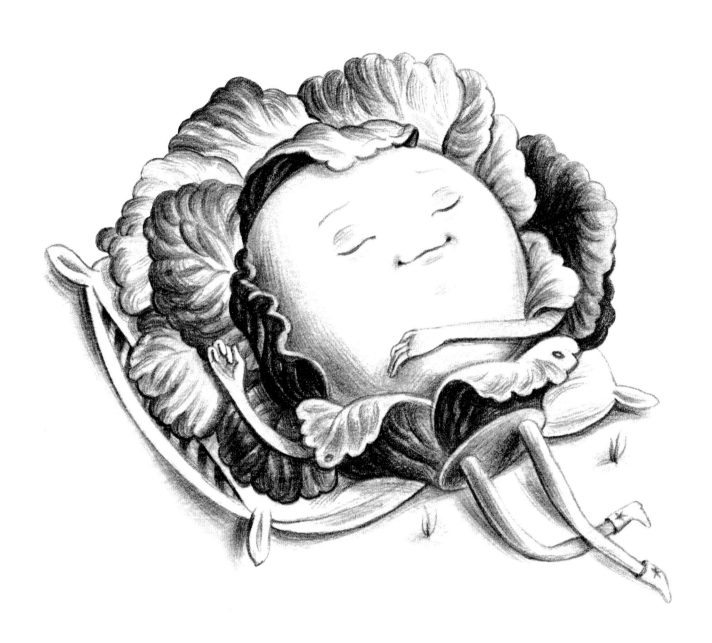

The Timid Cabbage

A poem by
CHARLES KRAFFT

Illustrated by
FEMKE HIEMSTRA

SYMPATHETIC PRESS
OLYMPIA, WASHINGTON

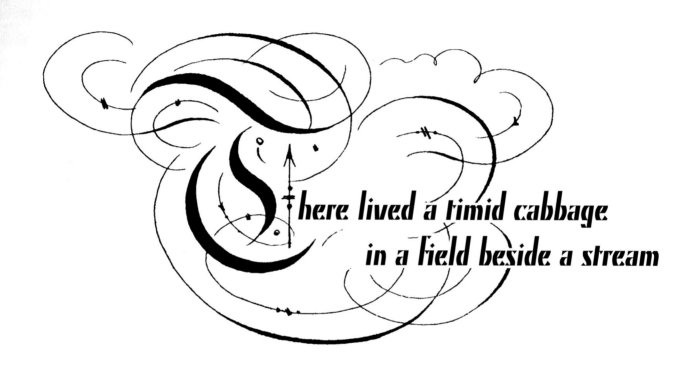

There lived a timid cabbage
in a field beside a stream

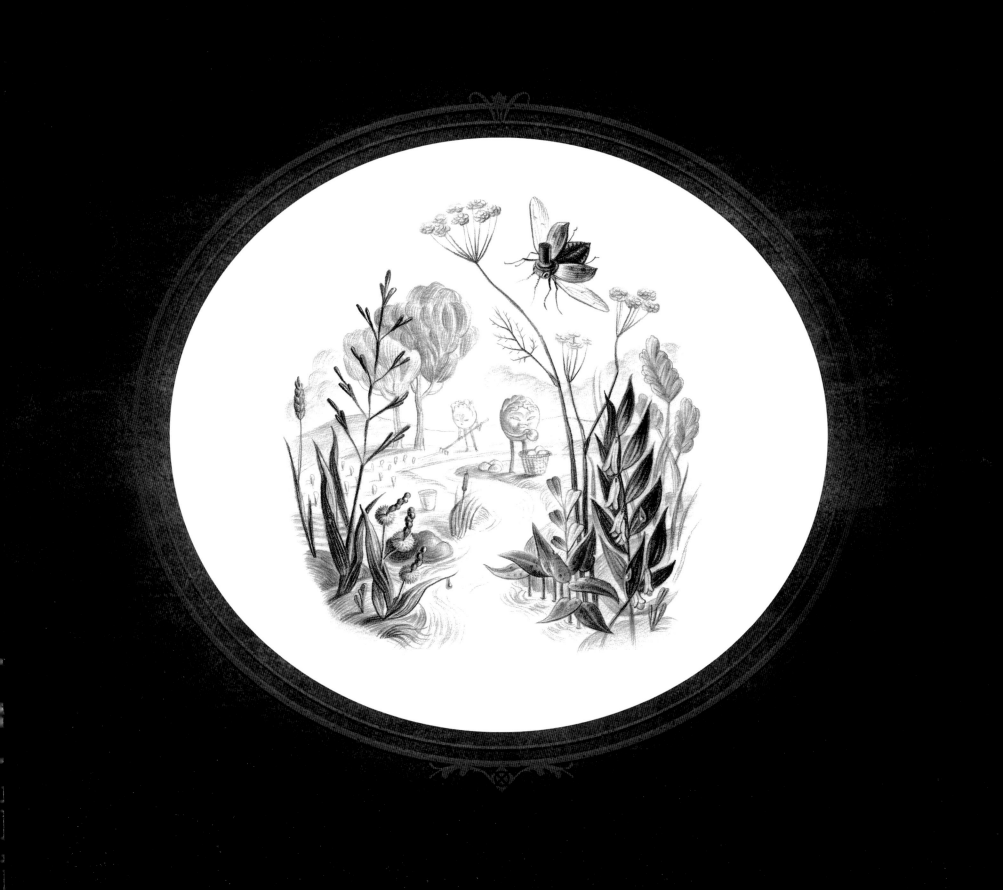

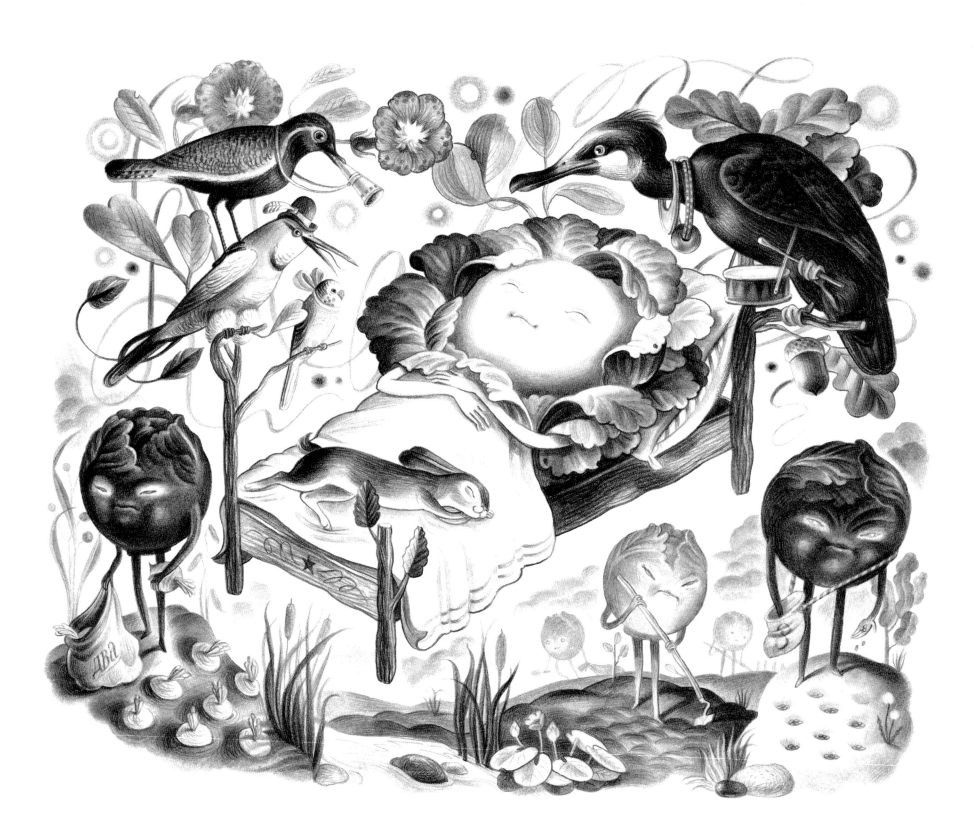

and all that cabbage did each day
was lie in bed and dream

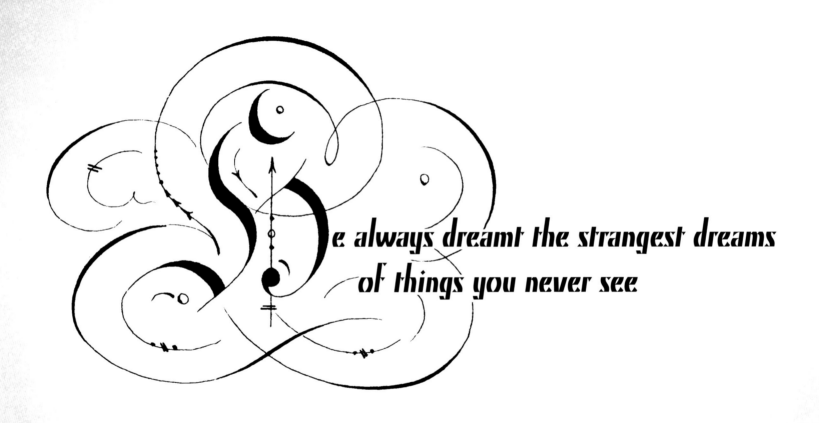

He always dreamt the strangest dreams
of things you never see

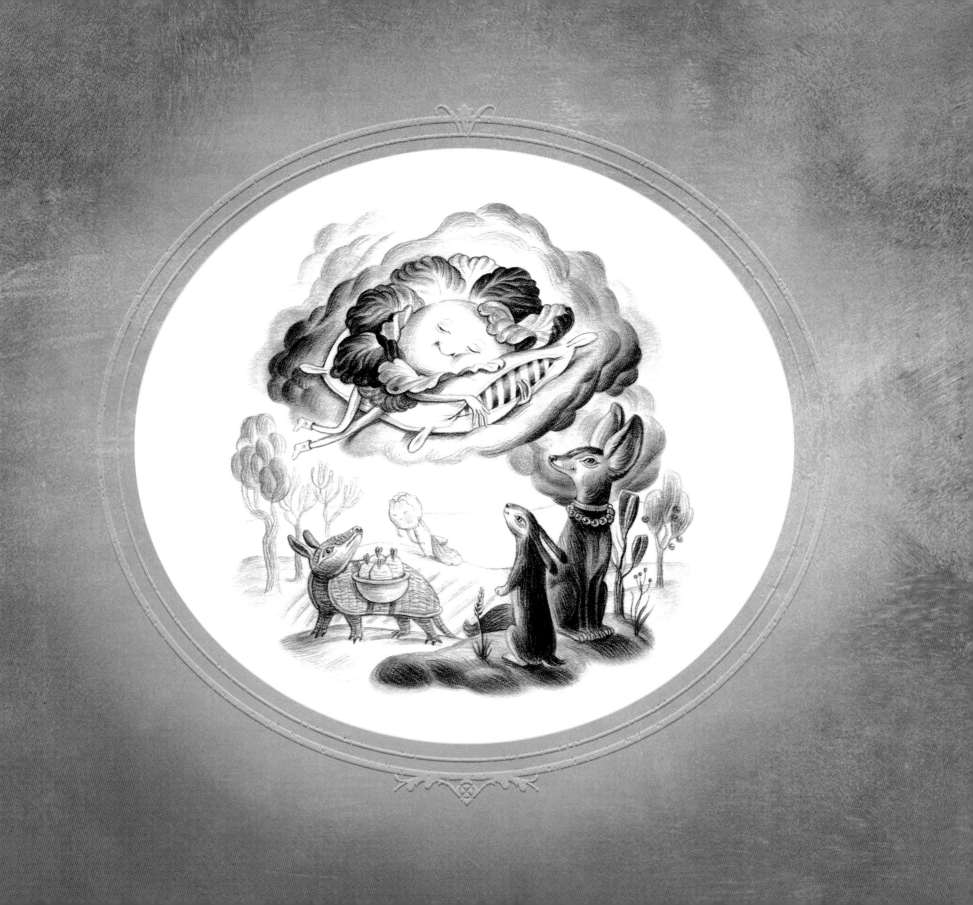

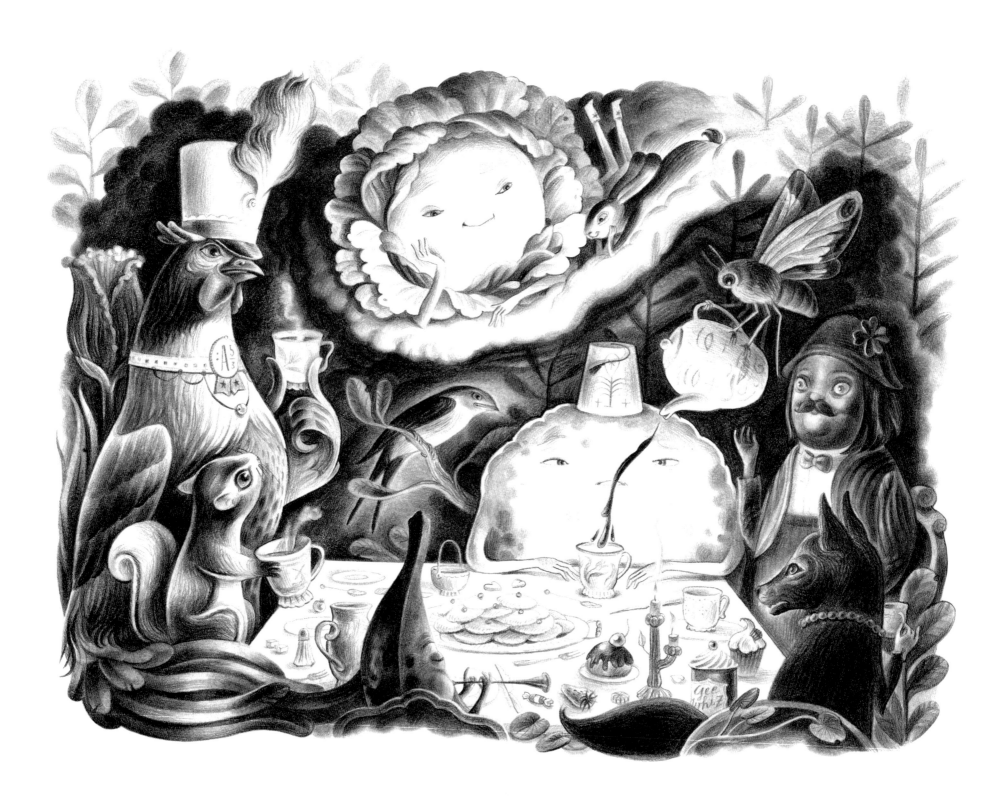

banana flutes and pancake roots
and cups of hot moth tea

ot all the other cabbages
who lived beside the stream

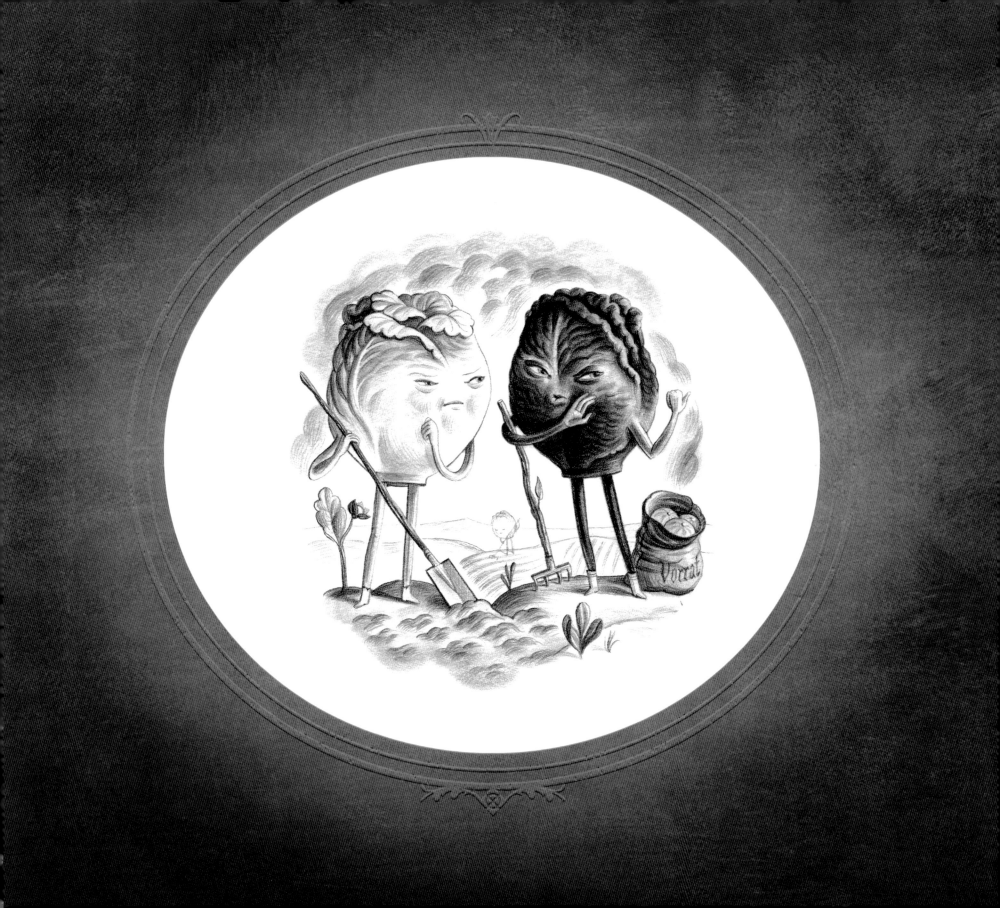

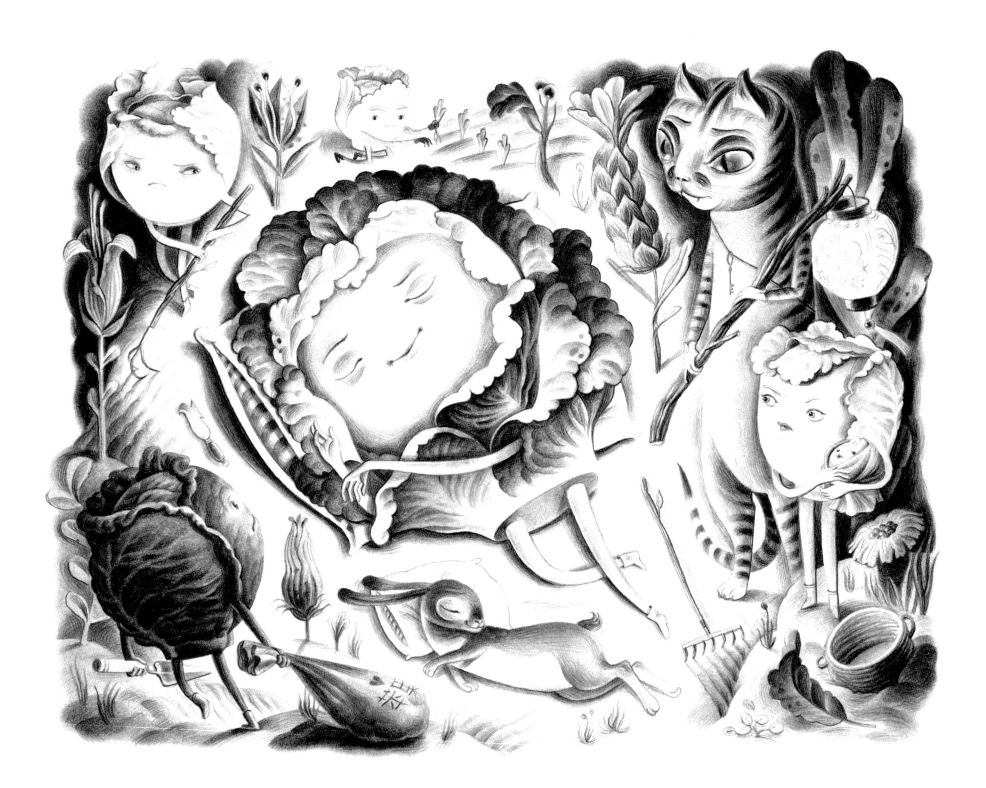

liked to have the timid cabbage
lie in bed and dream

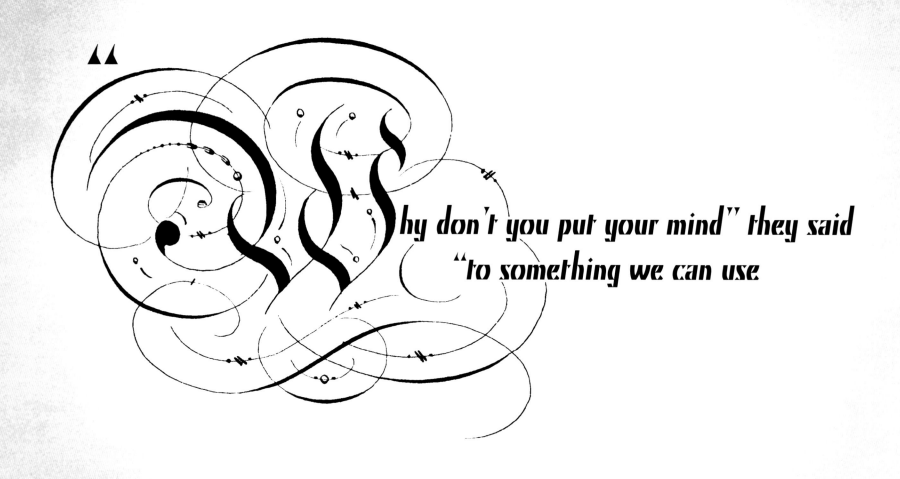

"hy don't you put your mind" they said
"to something we can use

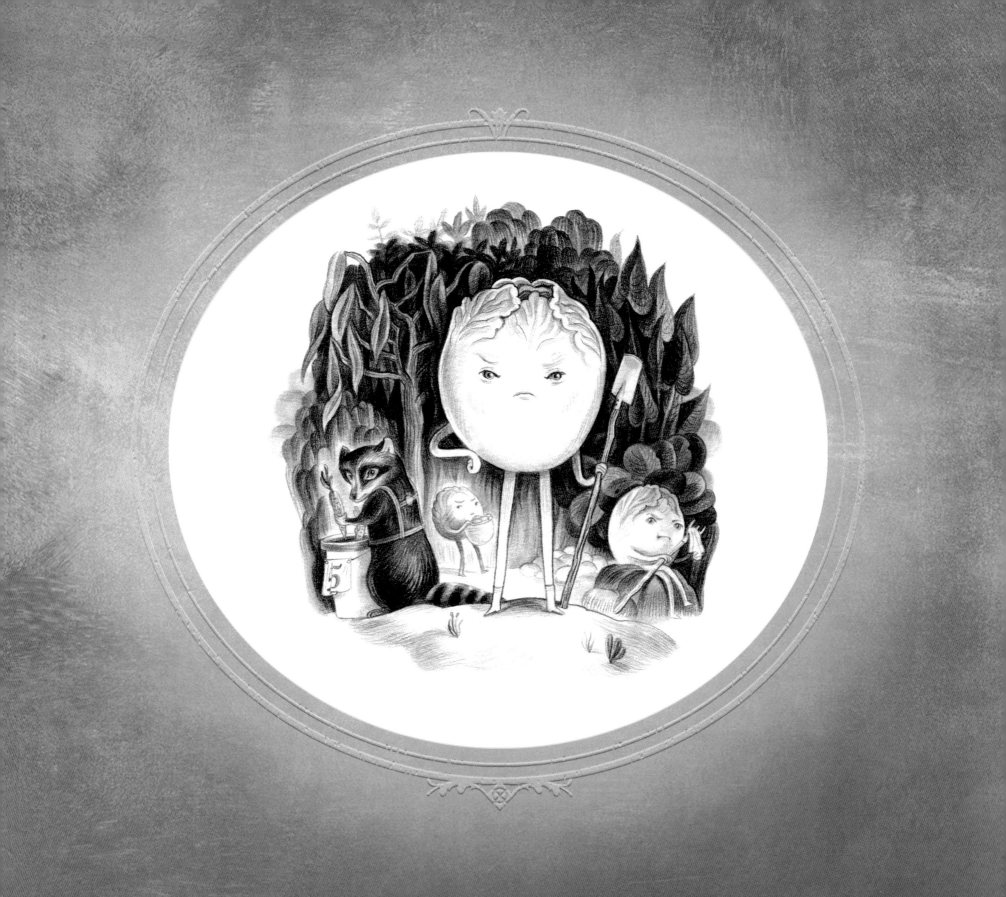

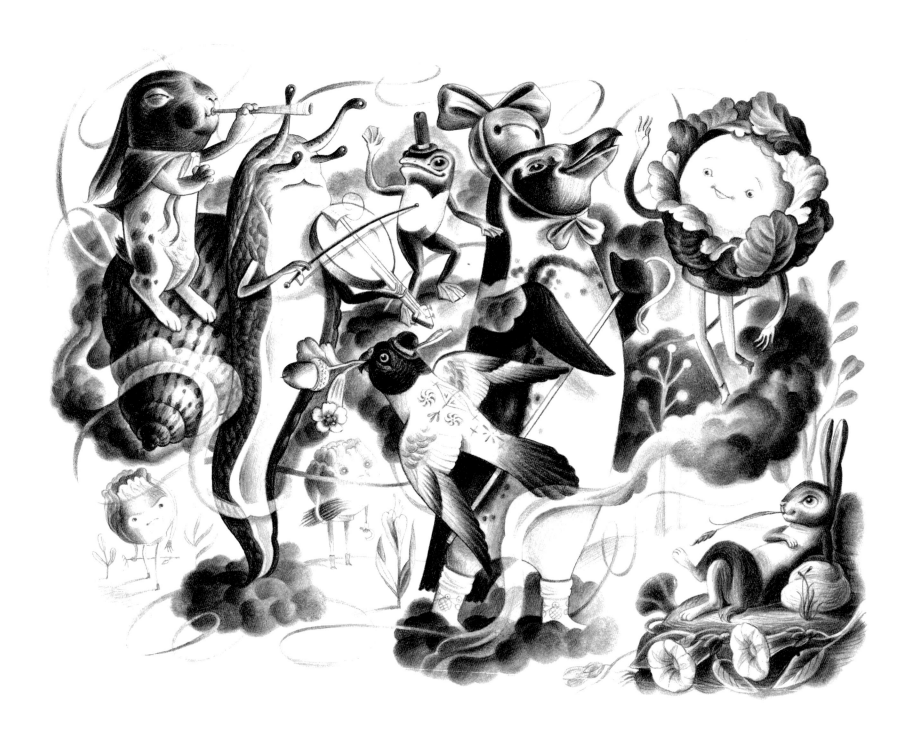

what need have we of fiddling snails
and pairs of penguin shoes?"

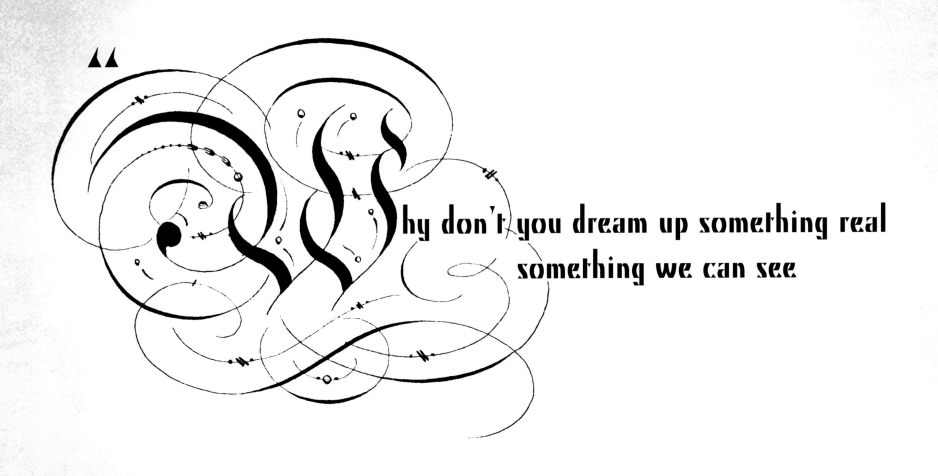

"Why don't you dream up something real something we can see

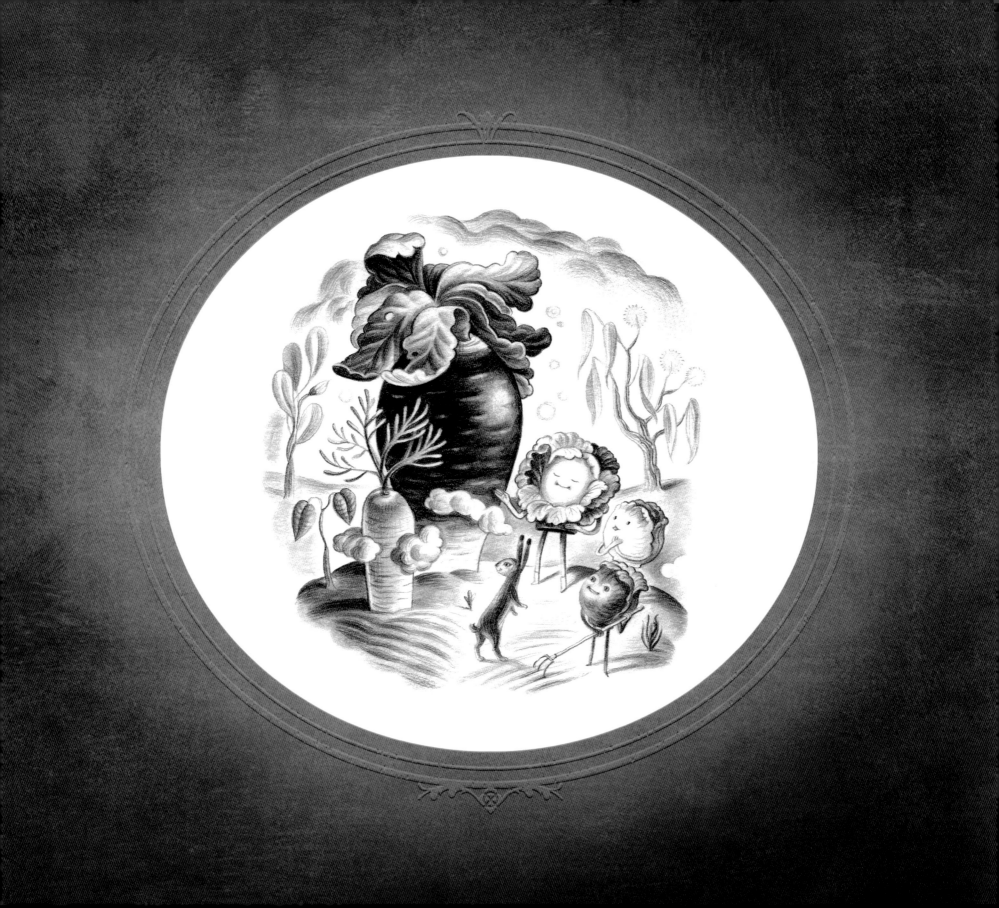

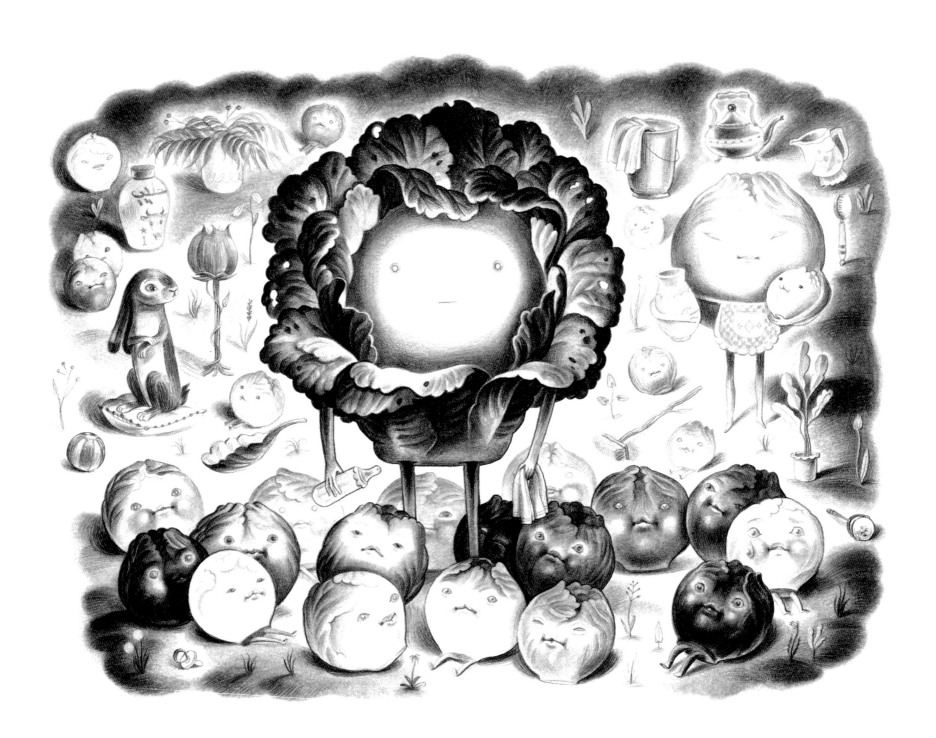

or find yourself a cabbagette
and raise a family?"

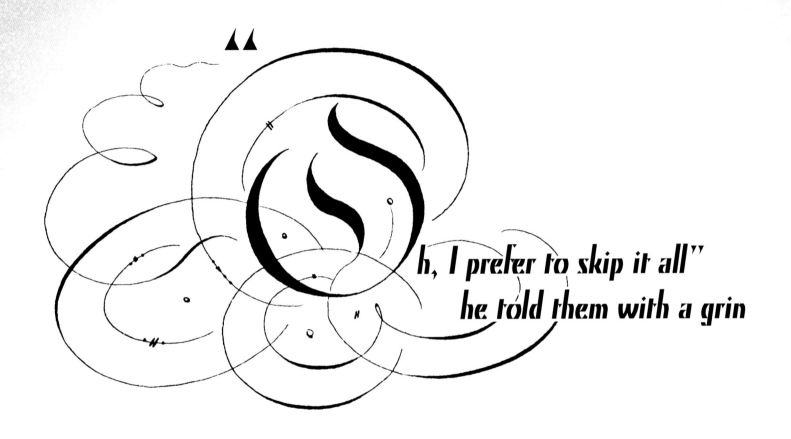

"Oh, I prefer to skip it all"
he told them with a grin

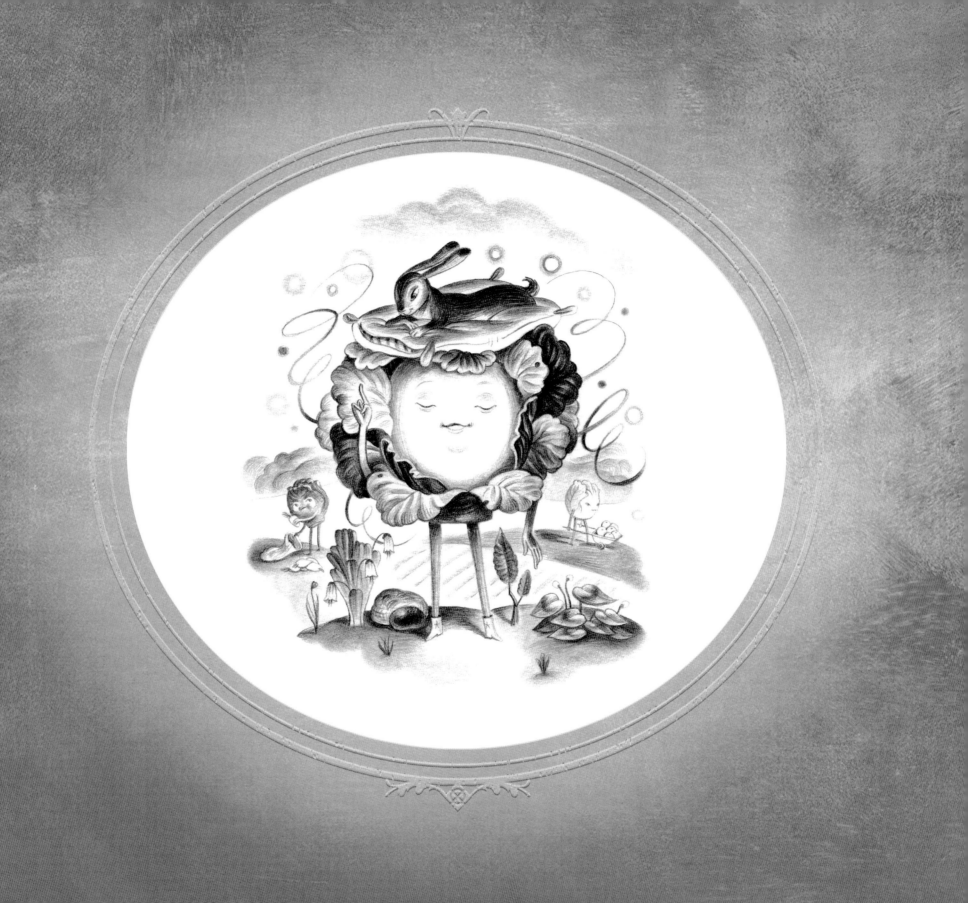

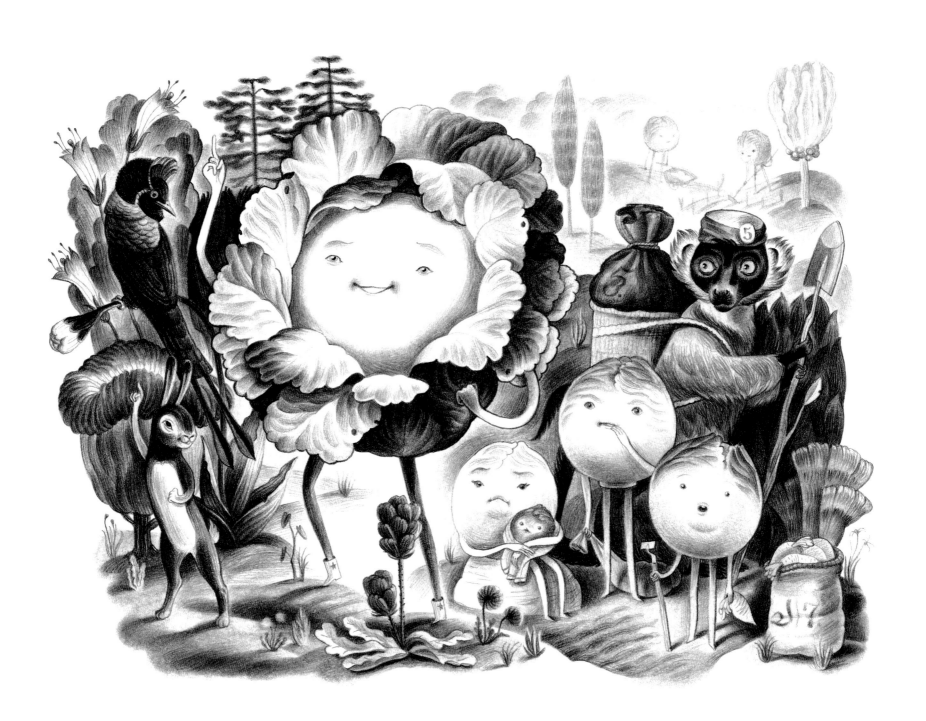

"because if I dreamt dreams like yours
I'd wear my patience thin"

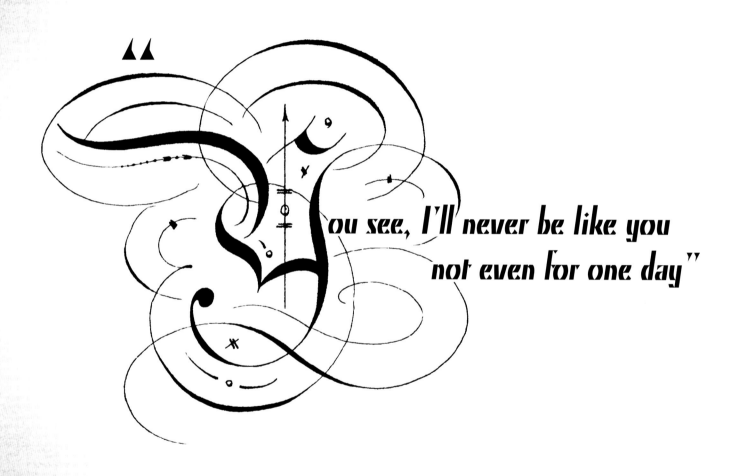

"You see, I'll never be like you
not even for one day"

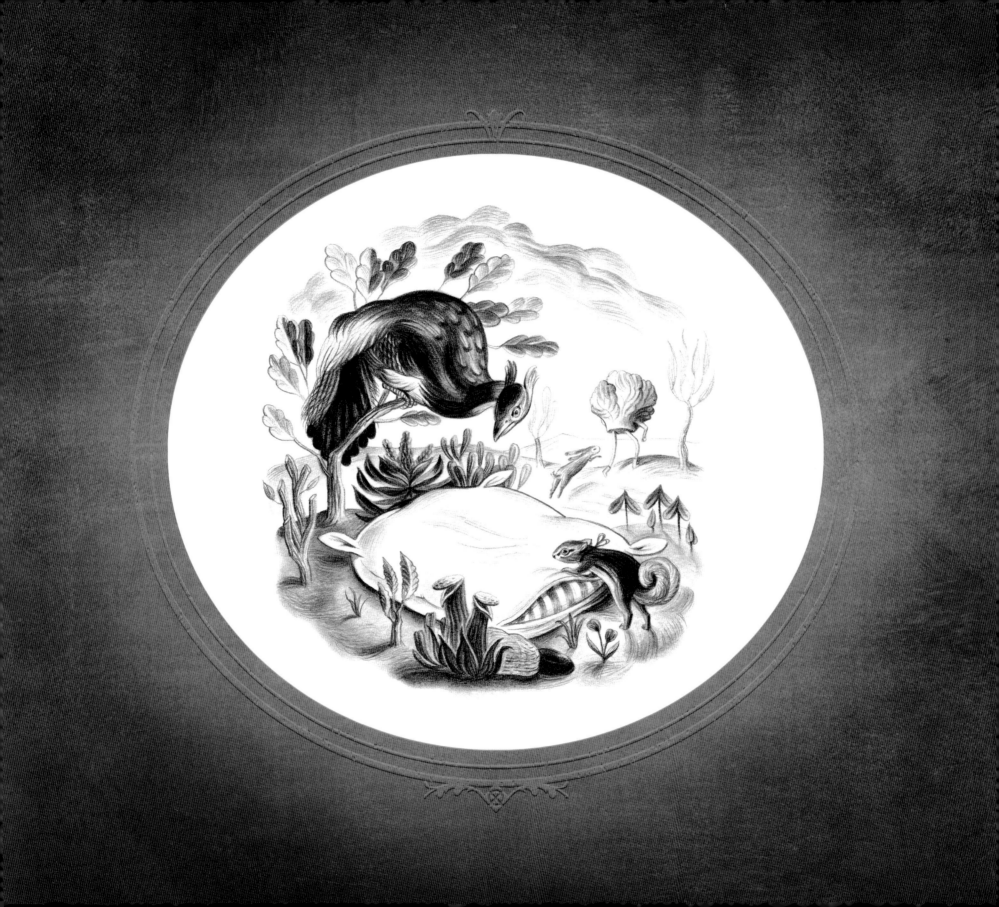

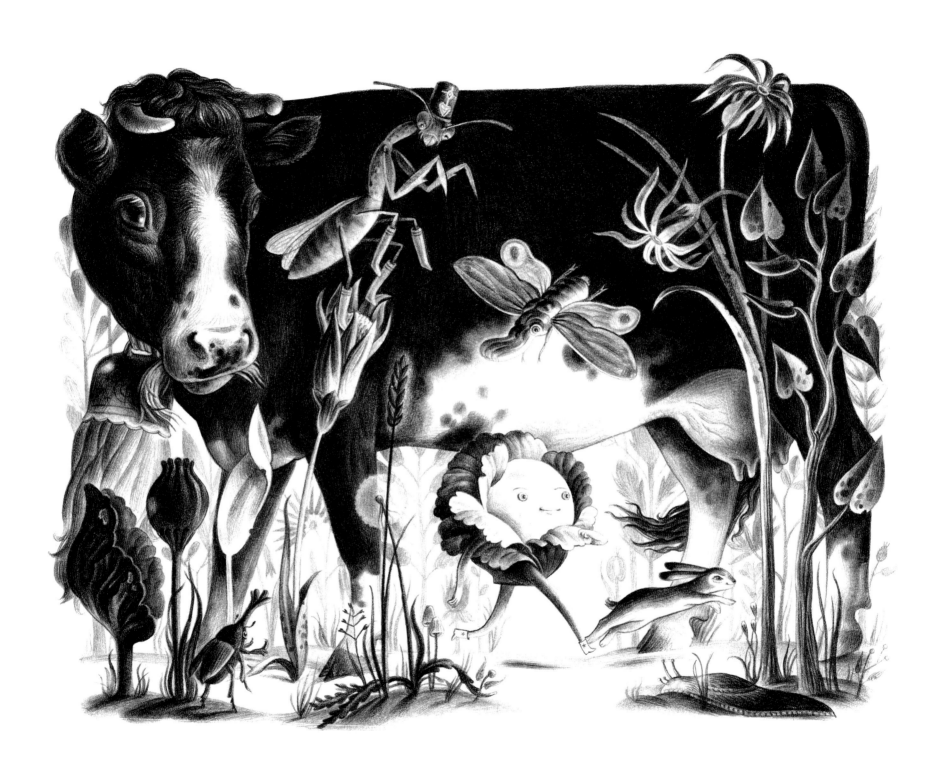

and with that he jumped out of bed
and then he ran away

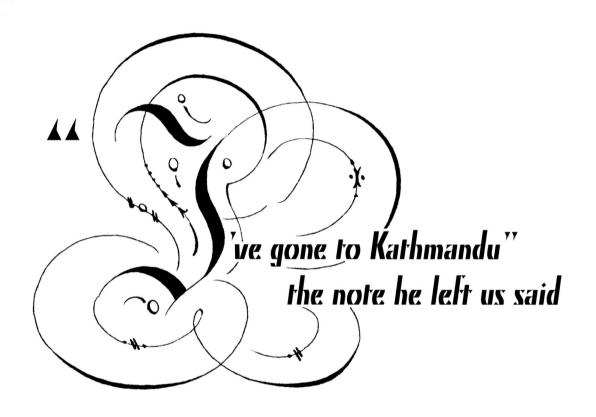

"'ve gone to Kathmandu"
the note he left us said

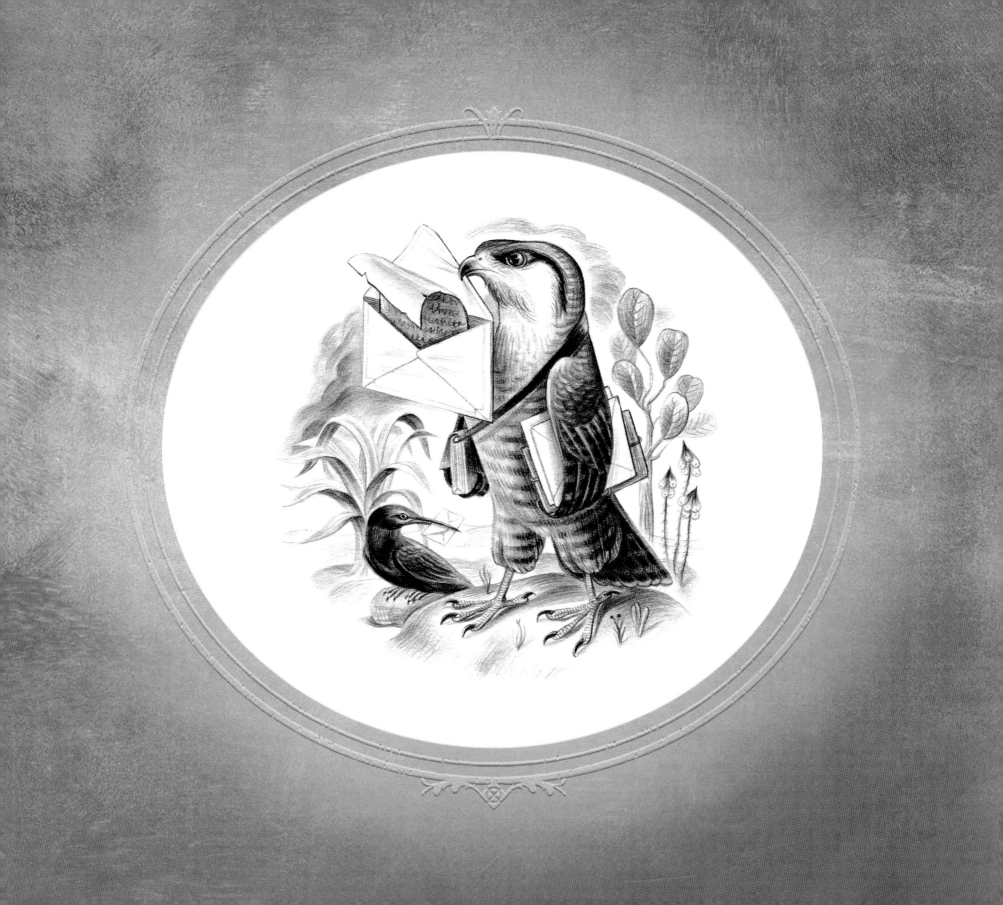

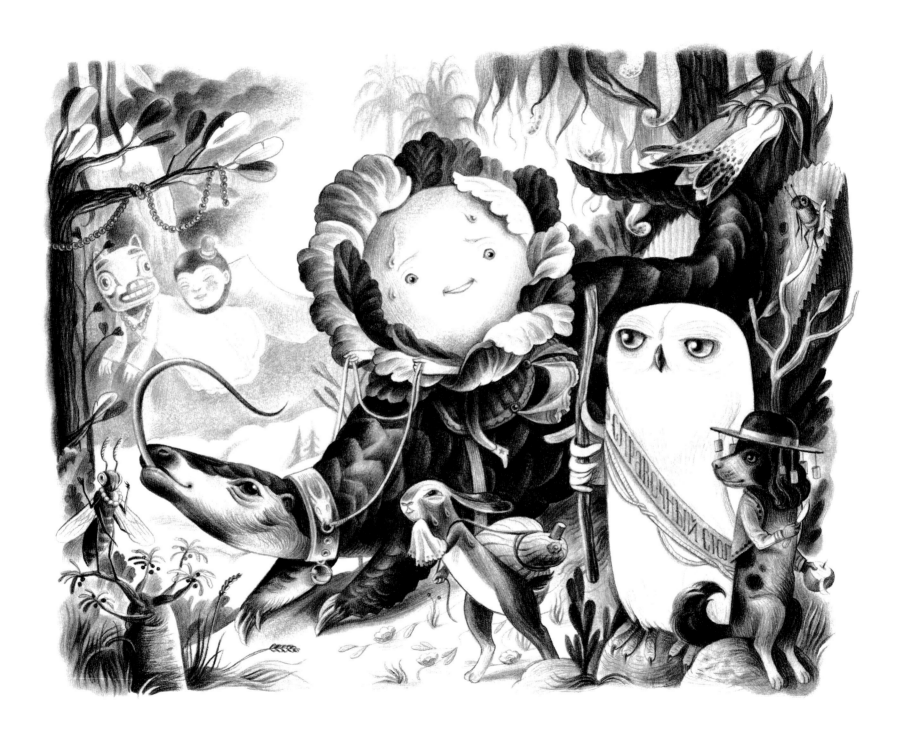

"there's a man up there I have to meet
whose beard is long and red"

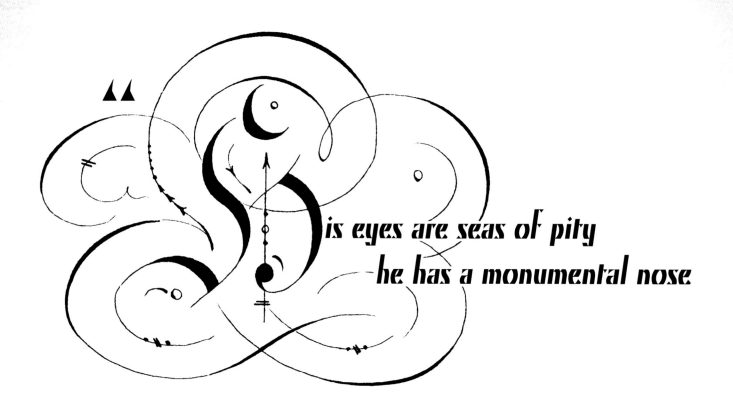

is eyes are seas of pity
he has a monumental nose

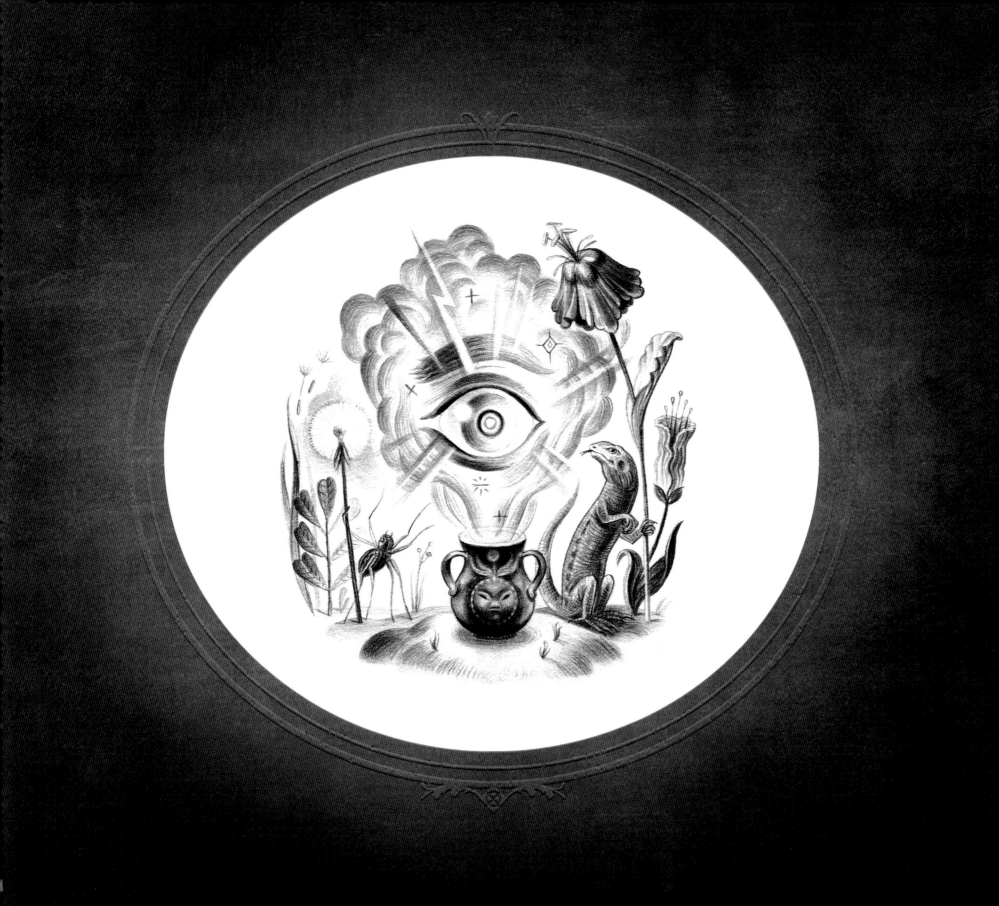

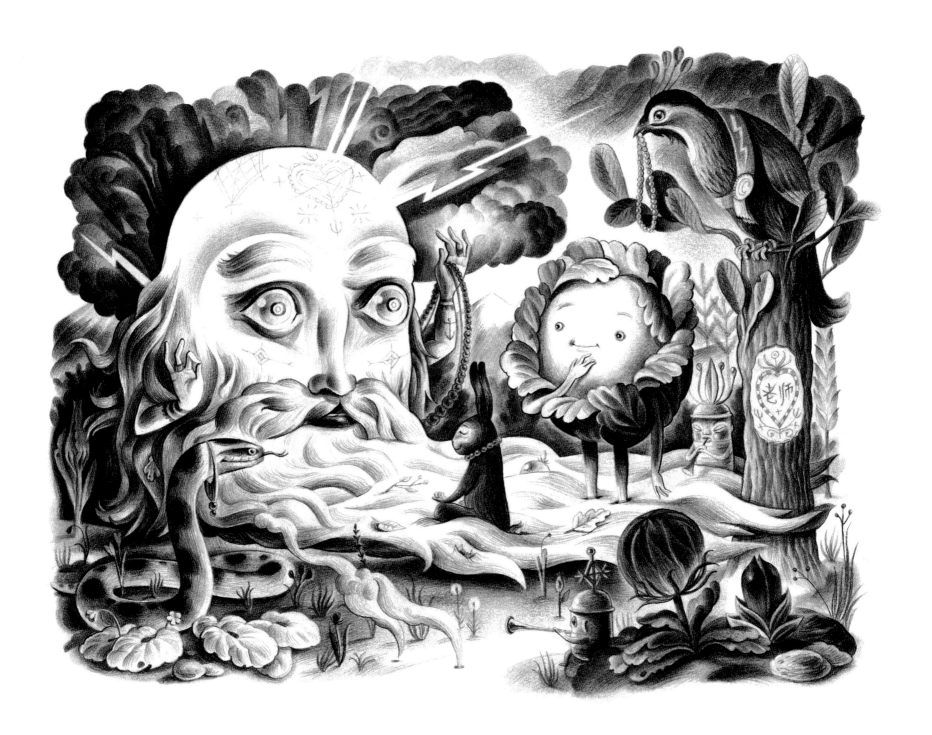

and he has the strangest habit
of never wearing any clothes"

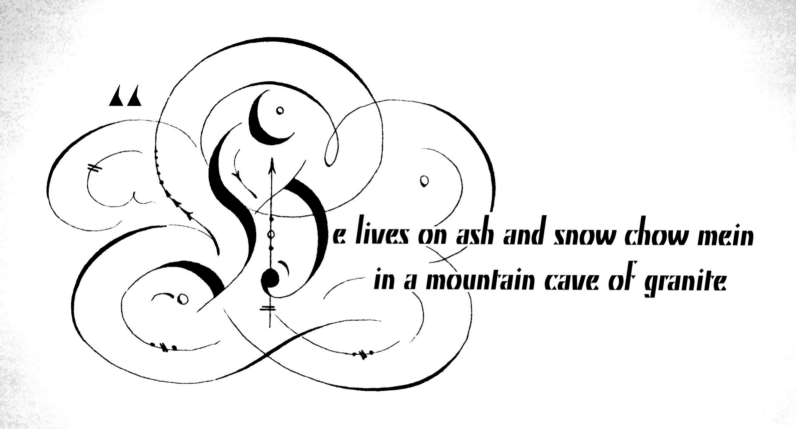

"He lives on ash and snow chow mein
in a mountain cave of granite

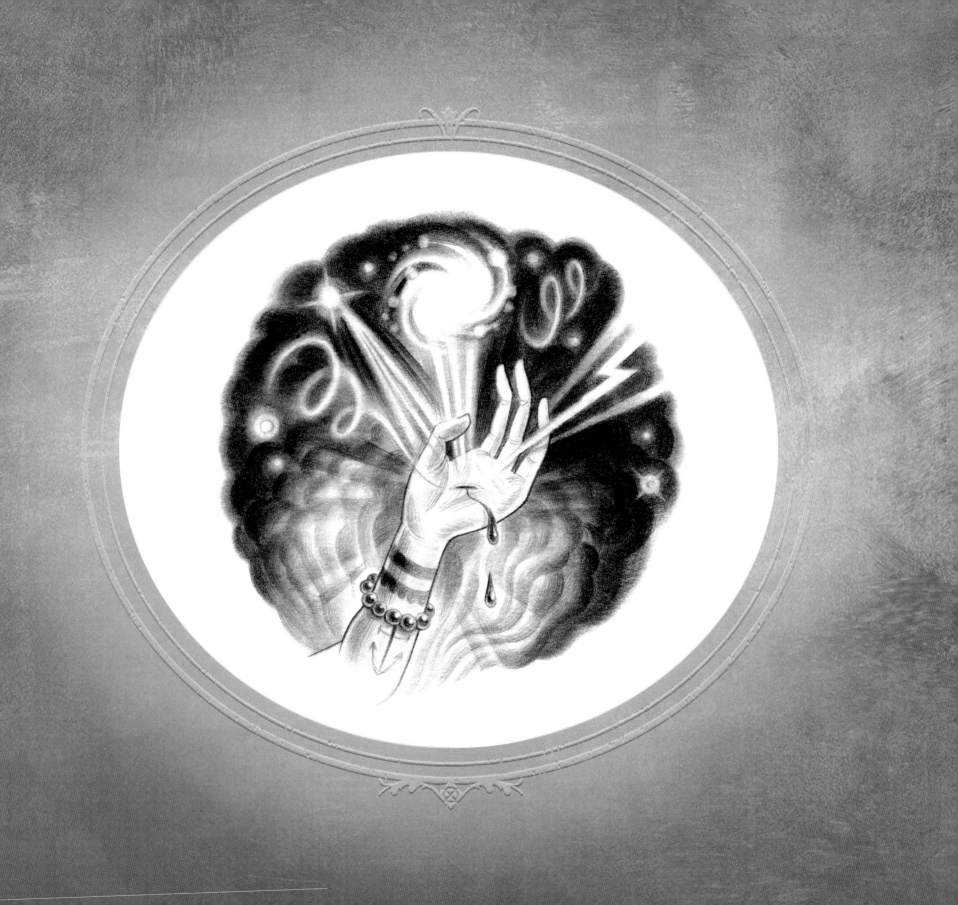

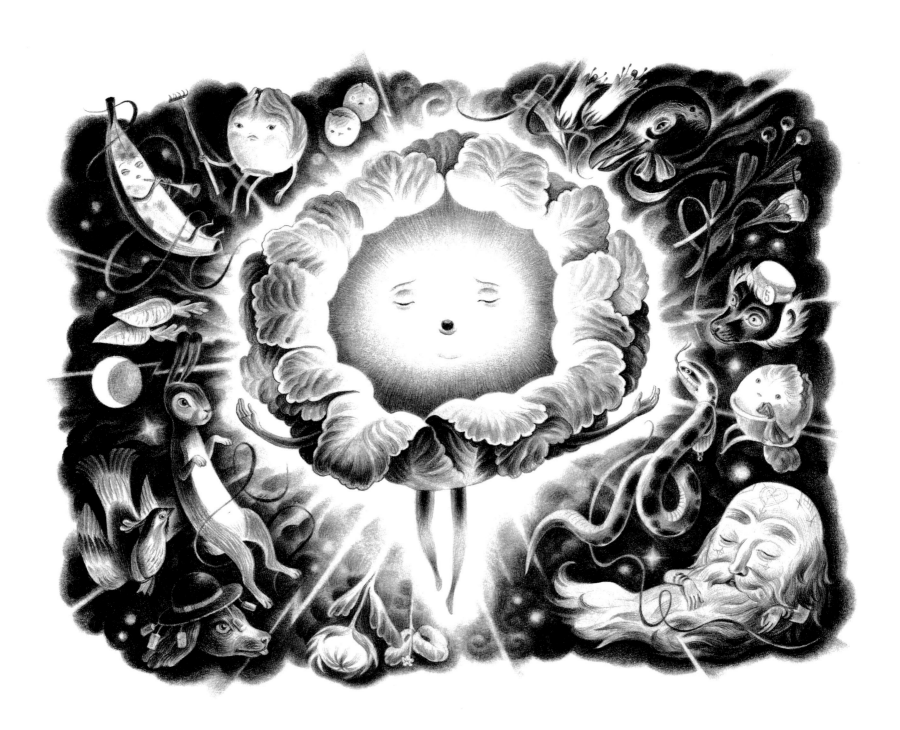

and he's often told me in my dreams
I'm not a cabbage but a planet"

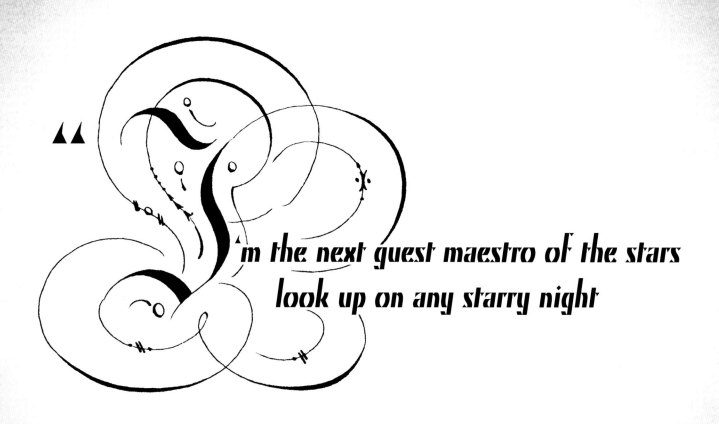

"'m the next guest maestro of the stars
look up on any starry night

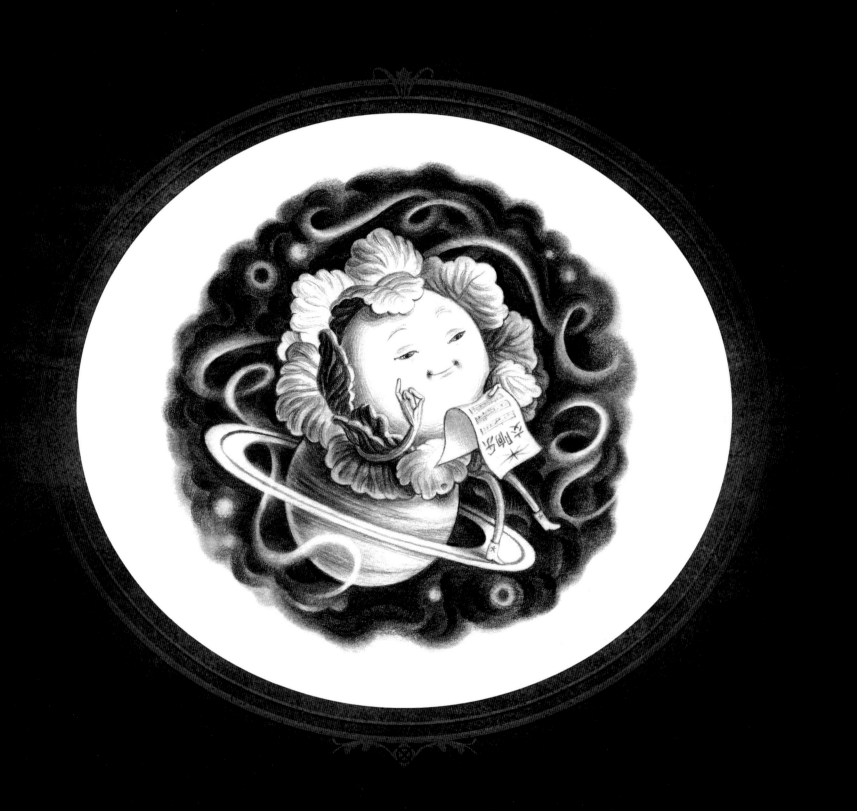

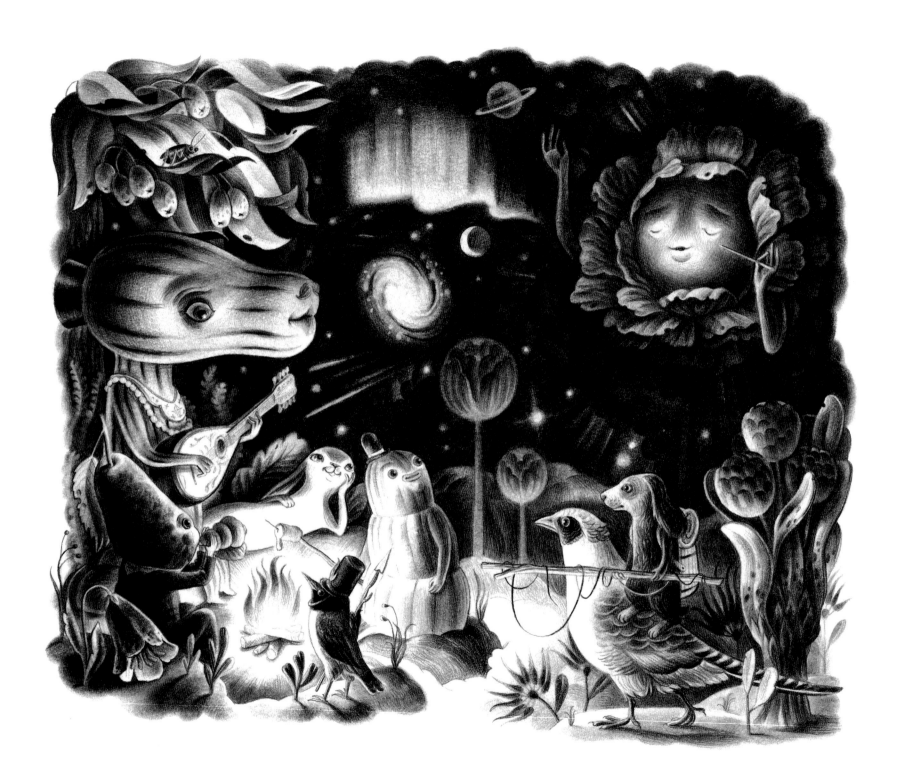

and you'll see me with my infinity baton

conducting symphonies of light"

— CHARLES KRAFFT

CHARLES KRAFFT

Charles Krafft is a native of Seattle, Washington. At age seventeen he ran away from home to become a beatnik poet in San Francisco, but was remanded back to Washington where he ended up focusing on visual art. His reputation in the world of contemporary American fine art and crafts was made after he took the prosaic Dutch Delft tradition of blue and white china and turned it into a vehicle for biting sarcasm about war, street violence and the egregious manipulation of news and history.

A self-taught artist in the tradition of the mystic painters of the Northwest School, Krafft hitched his wagon in mid-career to the Pop Surrealist legacy of the crackerjack American hot rod hero Von Dutch and the dense postmodern retro-avantgardism of Slovenia's NSK collective. This odd mix propelled him beyond regional respectability into international visibility. Krafft launched a lively art gossip column ("That Ain't Art!") for a local rock music newspaper and published in a variety of literary and life-style journals during the heyday of the 'zines. In 1985, novelist Tom Robbins presented him with a coveted Darrel Bob Huston Literary Award.

His website is www.charleskrafft.com.

FEMKE HIEMSTRA

Born and raised in Zaanstad, the Netherlands, in a nature-loving family, Femke Hiemstra wanted to pursue a career as a veterinarian. Then a forest ranger. And then 'something' with horses. But she ended up choosing the creative route, following the artistic call inside to pursue a career as a freelance illustrator. Her distinctive style quickly captured attention and she found success as a fine artist, showing in galleries across the globe and boasting an impressive collector and fan base.

Her dreamlike and cleverly humorous paintings and drawings traditionally feature anthropomorphic flora and fauna in darkly fantastical narratives. Hiemstra uses acrylic paint or graphite pencil on various found canvasses, and her work is shown at galleries in the US and Europe. She now calls the laid back Dutch capital Amsterdam her hometown.

Femke Hiemstra is represented in the US by Roq La Rue Gallery (www.roqlarue.com). Her website is www.femtasia.nl.

THE TIMID CABBAGE

Text copyright © 2013 Charles Krafft
Illustrations copyright © 2013 Femke Hiemstra

Published by Sympathetic Press
120 State Ave N.E. #134
Olympia, Washington 98501
email: sympathy13@aol.com

Publisher: Long Gone John
Editor: Kirsten Anderson
Book design: Femke Hiemstra
Design direction and production: Mark Cox

10 9 8 7 6 5 4 3 2 1
ISBN 978-0-578-12457-5 (Hardbound)

First printing 2013.
Limited to 1000 copies.

Special slipcased edition signed by the artist and author and containing a signed and numbered print by the artist limited to 100 copies.

Printed in China by Prolong Press Limited.

Thanks to:
Long Gone John
Kenny Yu and Anne Chan at Prolong Press